W9-DET-122

◆ CLOTHING ◆

You Are What You Wear

Helen Whitty
POWERHOUSE MUSEUM

This edition first published in 2002 in the United States of America by Chelsea House Publishers, a subsidiary of Haights Cross Communications.

Chelsea House Publishers
1974 Sproul Road, Suite 400
Broomall, PA 19008-0914

The Chelsea House world wide web address is www.chelseahouse.com

Library of Congress Cataloging-in-Publication Data Applied for.

ISBN 0-7910-6577-4

First published in 2000 by
Macmillan Education Australia Pty Ltd
627 Chapel Street, South Yarra, Australia, 3141

Copyright © Powerhouse Museum, Sydney 2000

Unless otherwise indicated, all objects featured in this publication are from the Powerhouse Museum collection. The Museum acknowledges the many generous donations of objects which form a significant part of the collection.

Please visit the Powerhouse Museum at: www.phm.gov.au

Curatorial advice: Lindie Ward, Glynis Jones, Peter Cox, Megan Hicks, Claire Roberts, Christina Sumner and Martha Sear, Powerhouse Museum
Photography: Powerhouse Museum including Penelope Clay, Marinco Kojdanovski and Sue Stafford (unless indicated in the picture acknowledgement)
Photo librarian: Kathleen Hackett
Research librarian: Ingrid Mason
Rights and permissions: Gara Baldwin and Judith Matheson
Heraldic crest: Sophie Daniel
Editorial and production assistance: Judith Matheson
Other assistance: Mandy Crook, Fleur Bishop, Stephanie Boast and Joan Watson
Powerhouse Publishing Manager: Julie Donaldson

Edited by Michaela Forster, em rules pty ltd
Text design and page layout by Polar Design Pty Ltd
Cover design by Polar Design Pty Ltd
Illustrations by Wendy Arthur

Printed in Hong Kong

Contents

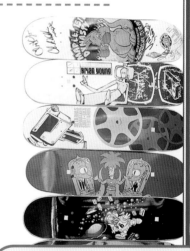

Don't turn this page!
Think of who you are and how you say it in the way you choose to dress. Consider any uniforms you might wear. See if you recognize any of them in this book.

Introduction

The things you wear on your body are your clothes. You probably have things you like to wear and things you have to wear. Your family probably likes you to wear special clothes for certain occasions. Sometimes what you like to wear and what your family wants you to wear are very different. Have you heard someone say, 'I wouldn't be caught dead in that dress/jacket/hat/shoes'? People can feel very strongly about what they, and others, wear.

▼ 'FUNK INC' poster from funkessentials, designed and made in Australia, 1993

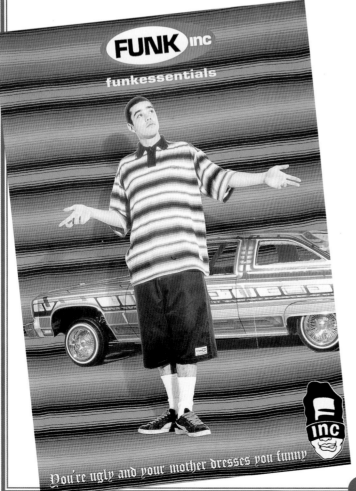

The story of clothing is about people's creativity and the ways they like to show it. What people make, wear and care about are examples of this creativity. What people wear says something about them. *Clothing* looks at wearing and making clothes across times, places and cultures.

Don't get dressed up to read this book — just dust off your imagination. Start off by imagining yourself without clothes.

Too revealing? The strange thing is, the more you cover up with clothing, the more you are really saying about yourself.

▶

Transparent plastic figure of a woman. It is full size, and shows the body organs, veins and arteries. It was made in 1954 to teach people about health and hygiene.

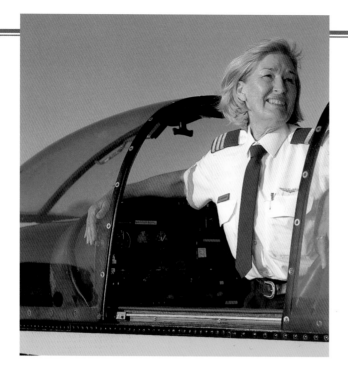

Others wear things to show they have done something or are about to do something. Soldiers and sportspeople wear medals. Men and women getting married wear special clothes.

The role of these people is told by what they are wearing—a police officer (below) and a pilot (left).

You are what you wear

Even if you do not think you dress for a particular 'look' or style, your clothes send a message. Some people have a job where they need to wear special clothes. People such as surgeons in their coats, priests with their long robes and the military in uniform all dress for their job. Close your eyes and think of royalty. Chances are you did not imagine a king or queen in a sweatsuit!

Even if you do not wear a uniform, you can still be part of a group. Some people wear surf clothes even though they rarely surf. They like the sort of people 'surfers' are, and want to be like them too. A starting point is putting on the clothes surfers wear.

Some people create their own style and fashion. The style is still a statement—it says something. The difference is that the message and clothing are unique to them.

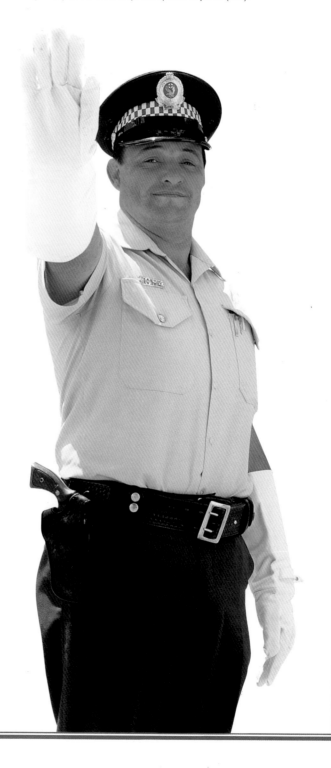

Nurses' uniforms

Uniforms are very effective in sending messages. They can say the wearer has authority (for example, a police uniform), is a member of a group (for example, a school uniform), or does a certain job (for example, a nurse's uniform). Uniforms set people apart.

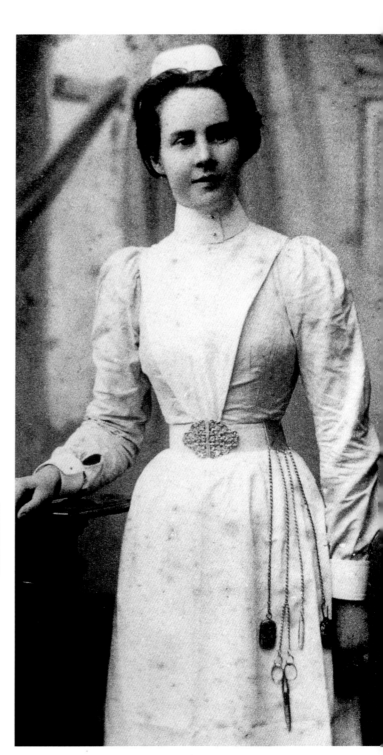

▲ A nurse's uniform worn from the early 1900s

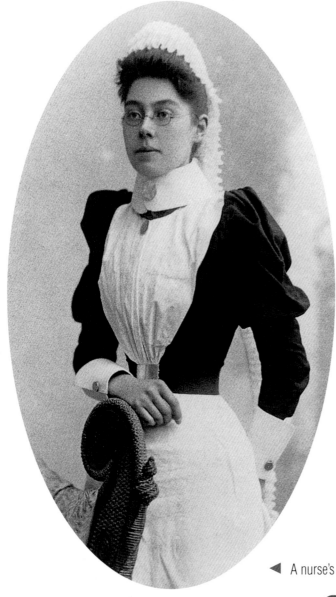

◄ A nurse's uniform worn before 1900

Florence Nightingale is famous for making nursing a respectable profession for women. She helped introduce the nurse's uniform. In 1860, Florence Nightingale started a training school for nurses at St. Thomas' Hospital in London. She had just returned from helping soldiers in the Crimean War.

For many years after, nurses at St. Thomas' wore badges and belt buckles cast from cannons used in this war.

Nurses' uniforms are a curious mix of styles taken from religious **habits**, army uniforms and servants' clothes. For example, nurses have stripes on their uniforms to show how important they are—just like soldiers.

▼ Nurses today wear 'friendly' uniforms.

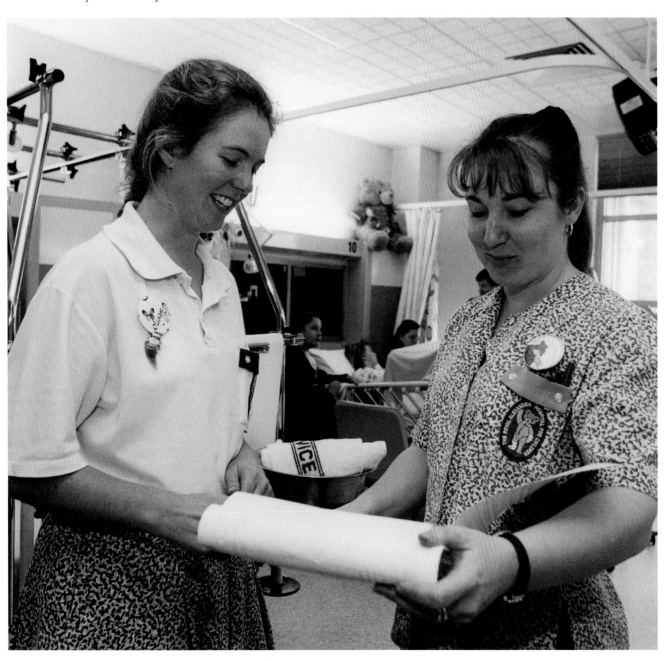

Chinese badges of rank

Since ancient times, Chinese people have used objects to represent feelings and ideas. For example, a **pomegranate** has many seeds and therefore represented many children. The word 'bat' is said aloud as 'fu' in Chinese. 'Happiness' is also pronounced as 'fu'. Therefore, a picture of a bat means happiness.

These badges below represent six of the nine ranks, or levels, of **civil** officials of the Qing **Court** (1644–1911). (Qing is pronounced 'ching'.) The badges were sewn on the back and front of overcoats. The rank of the wearer in court was indicated by the picture. Military officials had rank badges with pictures of animals on them. Civil officials had rank badges with pictures of birds on them. As birds can fly, it was believed that they were closer to heaven.

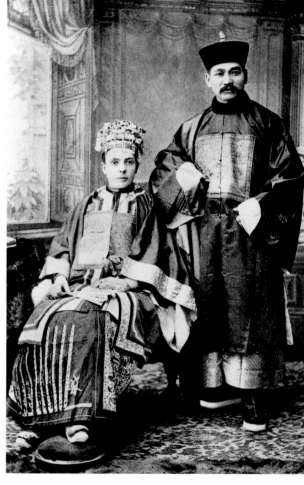

Crane

Silver pheasant

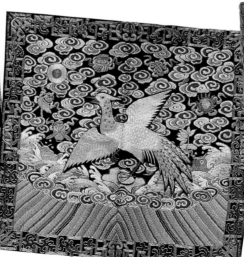

Egret

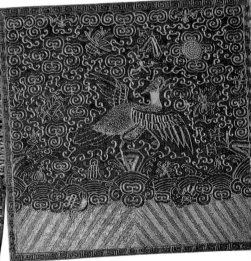

Rank	Civil official	Military official
First	Crane	Qilin (an imaginary animal)
Second	Golden pheasant	Lion
Third	Peacock	Leopard
Fourth	Wild goose	Tiger
Fifth	Silver pheasant	Bear
Sixth	Egret	Panther
Seventh	Mandarin duck	Rhinoceros
Eighth	Quail	Rhinoceros
Ninth	Paradise flycatcher	Sea horse

◄ This is Quong and Margaret Tart in Sydney, around 1880. They are wearing robes with the **insignia** of the fifth-ranking civil official. Quong Tart was a merchant who came to Sydney from China when he was seven years old. His wife Margaret was an Englishwoman.

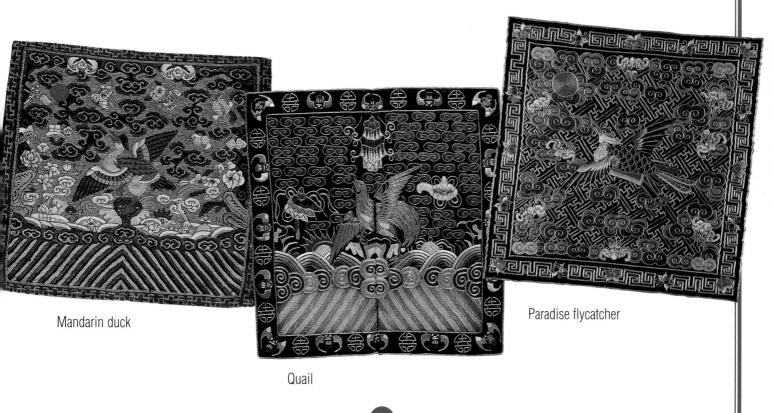

Mandarin duck

Quail

Paradise flycatcher

Color as a symbol

Color can be used to send messages. Different colors are used in road signs, packaging, maps and industry. The color red is used to signal a warning—it means 'danger'. Color in clothing can also communicate meanings.

Take away color and light, and you have black. Black is connected with grief, chaos and sorrow. In western cultures people are likely to wear black to a funeral.

Blue tells of peace, coolness, wisdom and loyalty. The Virgin Mary has a blue cloak. It can also tell of sadness—'Are you feeling blue?'.

White suggests light, perfection and simplicity. In western cultures, brides wear white. However, in Asian countries, white is worn in **mourning**. Aboriginal people painted their bodies white to connect with the spirit world. Hindu women whose husbands have died wear a white cotton **sari**.

Brown represents the color of the earth. Some religious communities wear it to say that they are not concerned with worldly possessions such as money.

Yellow is the color of the sun and suggests light, life and truth. Yellow can also mean cowardice—when someone is not as brave as they could be. A yellow flag outside a building warns of quarantine—there is a disease in the building that you could catch. A yellow flag on a ship means that there are no diseases on board.

Green can suggest hope and gladness but also change and jealousy. For Muslims, green is a sacred color.

Purple suggests royalty, pride and ritual. In Roman times, purple dye from the **murex** shell was very expensive and was used by important people on the border of their clothes.

Red represents the sun and all war gods. The Chinese see red as the luckiest of colors and dress brides and children in it. Christian saints' days are called 'red-letter days'.

The baggy green cap

A baggy green cap is worn by cricket players chosen to represent Australia. In May, 1908, the Australian Cricket Board chose bottle green and gold as the colors of the Australian team.

Cricketer Steve Waugh said, 'When you're playing as a kid in the backyard…the ultimate goal is to wear the baggy green cap. That was my goal. Even now kids will say, "Hey Steve, give us your cap", I say, "No mate, you've got to earn one of those".'

(From *The Baggy Green* by Viv Jenkins, New Holland, Sydney.)

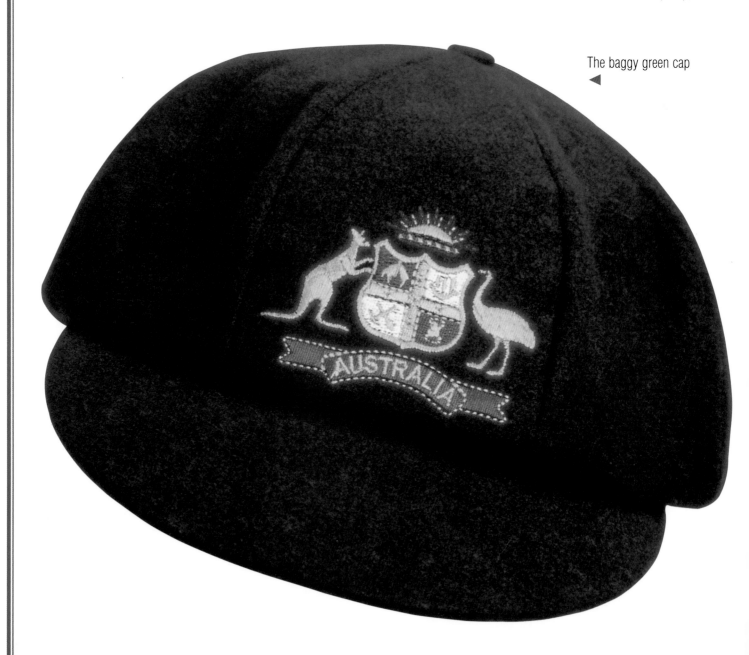

The baggy green cap
◄

Medals

People can perform acts of bravery or achieve something of which they are very proud. They tell those around them of their deed by wearing medals. The medals may only be worn at certain times but still say a lot about the wearer.

*Did ye feel your pulses beat
As ye, marching, moved this morning
All adown the cheering street?
In your federated freedom
In your manliness allied
While the Badges of your Labour
Were the Banners of your Pride.*

A poem written to celebrate the anniversary of the Eight-hour Day, by Marcus Clark, 1876.

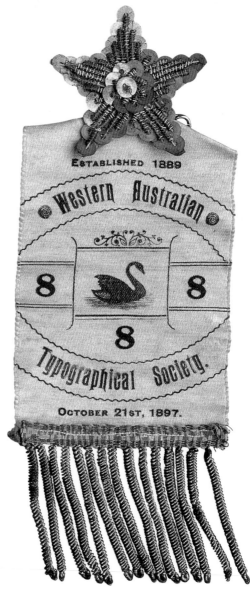

▶ This badge marks the winning of the eight-hour working day by unions in Western Australia.

ESTABLISHED 1889

Western Australian

8 8
8

Typographical Society.

OCTOBER 21ST, 1897.

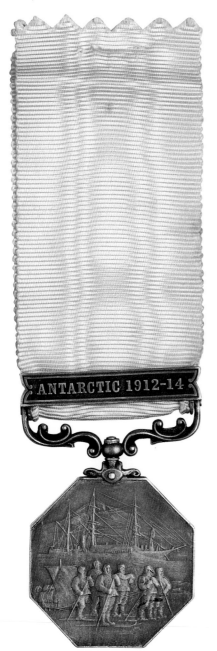

ANTARCTIC 1912-14

◀ This medal belonged to C.F. Laseron. He was part of the Mawson Antarctic expedition of 1912–14.

Heraldic crests

A heraldic crest belongs only to one person or family. In the days before most people could read, the crest said where the person came from, who their family was and what sort of person they were. Crests identified cities, kingdoms and special groups. They were a form of code. The crest had sections, each with a different pattern. Pictures were placed in the sections. The pictures could be real or imaginary animals, such as lions or dragons, armor, fruit, or other symbols. Pictured right are some patterns of crests.

Some crests also had a sentence called a motto underneath. In Europe, mottos were often written in Latin. Here are some examples of mottos.

Latin	English
excelsior	ever upward
dum spero, spero	while I breathe I hope
semper fidelis	ever faithful
semper paratus	always prepared
bona fide	in good faith
carpe diem	seize the day
nulli secundus	second to none
pax vobiscum	peace be with you
veni, vidi, vici	I came, I saw, I conquered
ad astra	to the stars
ne plus ultra	perfection

Make a heraldic crest

What you need

- a computer running 'Kidpix studio'
- If you do not have access to this computer program, you could photocopy the crest on page 16 and draw your patterns and pictures directly onto it. Don't forget to write your motto!

Step 1

Transfer the crest template onto the disc drive. An easy way to do this is to photocopy the template on page 16. Cut around the edges of the photocopied template, and then stick it to the screen of your computer. Select 'pencil' from the Kidpix menu and trace round the outside of the cut-out. Click 'file' and 'save a picture'. Go to the 'C' drive. Call your picture 'crest.bmp', then click 'save'.

Step 2

Click on 'file' and 'import/open picture'. Click on 'crest. bmp' and then 'OK'. The crest outline will now be on the screen.

Step 3

Make a pattern on your crest. Click on the pencil in the tool bar. Choose a color by clicking on the color palette at the bottom left-hand side of the screen. Using the pencil, draw straight or wiggly lines. You can also click on the picture of a line and choose the line thickness for the pattern. Click on the screen and, holding the mouse button down, move the pointer to where you want the line to go.

Turn to page 16 for steps 4–7.

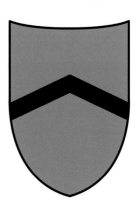

Step 4

Write a motto in the ribbon on the template.

Step 5

Click on the 'bucket' to select it. Choose a color and if you want, a pattern from along the bottom tool bar. Once you have chosen a color and pattern, all you have to do is click inside a shape and the bucket will color it in for you. If you do not like the color the 'oops man' will get rid of it. Click on him and the colored bit will disappear.

However, he will only undo the last thing you did. The 'eraser' (it looks like a red brick) can also rub out.

Step 6

Select a picture. Click on 'stamp' in the tool bar. Click in the sections on your crest where you would like a picture. You can find more stamps by clicking on 'goodies', and then 'pick a stamp set'.

Step 7

Print your crest. Set 'print set up' to 'landscape'. Press 'print' under 'file'.

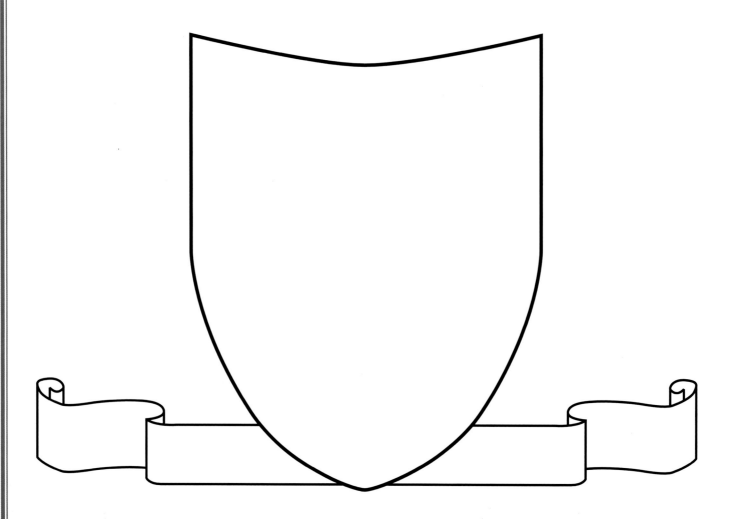

Regalia

This **regalia** belonged to a member of a club called the Royal Antediluvian Order of Buffaloes. The club had a number of ranks that members moved through. The owner of this regalia was among the highest ranks in the Buffaloes— he was a knight. To signify how important this position was, he wore these decorations.

Mobile phones

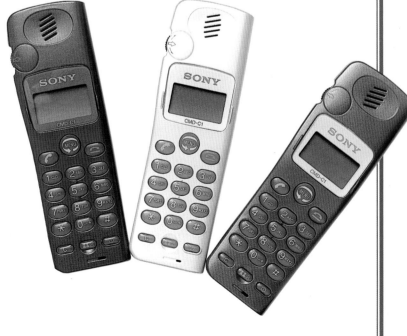

Mobile phones can be part of a 'look' or fashion. Once mobile phones were uncommon and expensive—you could look wealthy just by having one. Now many more people, especially young people aged between 18 and 24, have a mobile phone. They are becoming part of costume and fashion like these Sony CMD-C1 mobile phones that come in a range of colors. Backpacks have mobile phone pouches for easy access, and pants have special phone pockets.

Skateboarders

The first skateboard may have been made from a fence paling and roller skates. Another story says the skateboard evolved from a scooter in the 1950s. Skateboarding is very popular today. There is a certain style of clothing worn by those who regularly skateboard. Skateboarders wear cotton drill baggy pants, baseball caps, 'fat' shoes, and loose-fitting T-shirts.

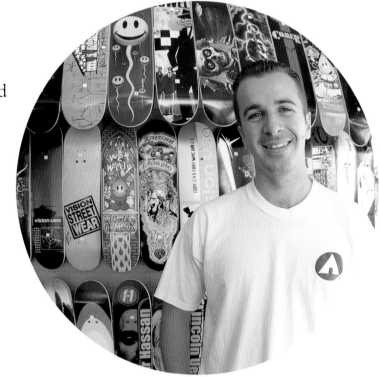

▲ Simon Siounis in front of some skateboard decks in the shop Skateboard World.

The most popular clothes are made by companies that also make the skateboards. Young people often choose the skateboard they ride because they like the picture on the **deck** and they like the look of the clothes. Skateboard companies include Birdhouse, Hookups, Flip, World Industries, Alien Workshop and Powell.

▲ A skateboarder in action

Surfers

Mambo

Mambo is a surf fashion label. It was started by a musician and artist called Dare Jennings. He gathered up friends from art school, including members of the band Mental as Anything, to make pictures that could be used on clothing. The label is very successful. It has images that people think are funny. Jennings once said that the reason for Mambo's success was that the humor is 101 percent Australian. Mambo made its clothes into a kind of club. People wearing the clothes are sharing a joke and saying something about themselves.

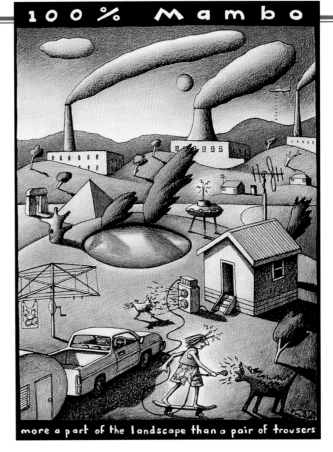

▲ A Mambo poster designed by Chris O'Doherty (Reg Mombassa), Sydney, 1988. 'More a part of the landscape than a pair of trousers' means that the clothes are more than just something to wear.

'Loud shirts' designed and made by Mambo, 1999. Mambo is an Australian surf and streetwear company. Mambo says, 'We don't just make clothes, we make news.' Mambo's costume is more than clothing and accessories—it is a lifestyle.

▼

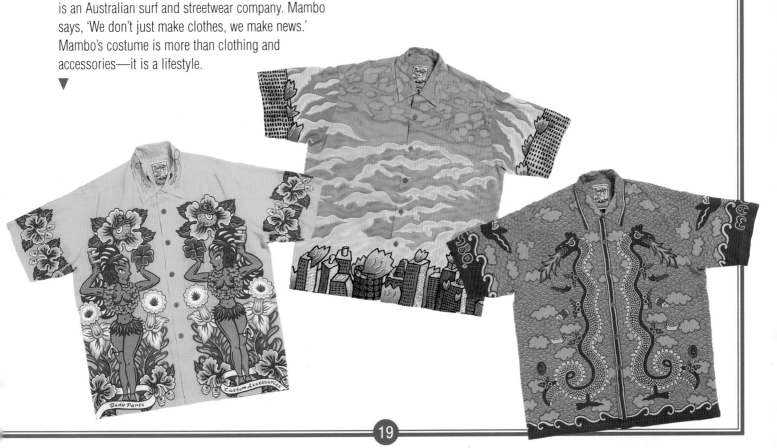

19

Meet
Steve Dixon,
artist

Shayne Martin (left) and Steve Dixon of Doolagahs Surf Products first met while surfing. They had an argument! Deciding to talk through their difference of opinion, they became friends.

What is a Doolagah?

The legend of the Doolagah reaches far back into Aboriginal culture. He is a Dreamtime legend, a wild hairy man of the bush. People say he is large with red powerful eyes, large hands and feet, and a terrifying roar. He is a symbol of power but also respect. As an artist, I make pictures that can be used on fabric and clothing to remind people to protect and respect the natural environment.

▼ Some Doolagahs T-shirt designs

As both a **Koori** and a surfer, respect for the environment is very important to me. The meaning of the Doolagah is part of my art and the products we make.

What are Doolagahs Surf Products?

The Australian **Indigenous** surf brand which makes clothes to wear surfing, swimming, on the street. There are two other main people in Doolagahs. Shayne Martin is the concept creator who lives on the south coast of New South Wales.

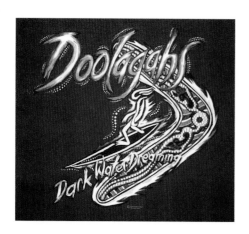
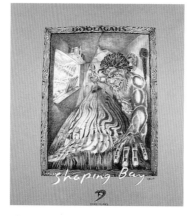
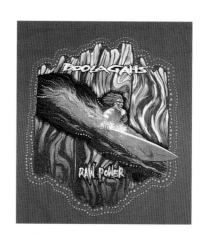

▶ A Doolagah might look like this— powerful and fierce. Designed by Steve Dixon of Doolagahs Surf Products.

He is an excellent storyteller and didjeridoo player who tells people about his Koori culture and beliefs. Kenneth Swan is the manager. He has many years experience in business—both screen printing and manufacturing. Doolagahs Surf Products show Koori surf art. This art form puts Aboriginal stories into a picture or sculpture. All stories are treated with great respect.

Tell me how you make your artworks.

Shayne and I talk about Koori stories. We might be in the surf together or walking in the bush, and something we see starts us thinking about the Aboriginal meaning, use or importance. For example, it might be a dolphin we see and talk about its story or its Koori names. I make a picture using pencil or ink. Often I use information technology [computer equipment]

by scanning this picture and coloring it on the computer. As the picture may be used in screen printing, I must separate out each color on different screens. It is easier to do this on computer.

What is your training?

I went to art school for three years and got a traineeship in Newcastle. I taught myself computer skills.

Where to from here?

With our next range, we are going to focus on rural communities. We want to hear what they think about it and tell others. This way, we can represent more Aboriginal culture and maybe bring people and communities together with our stories. We want to continue to work in something we love, and explore new ideas and how to relate them to Indigenous people. These new ideas might be on new ways to do business. We may hold business meetings in the surf!

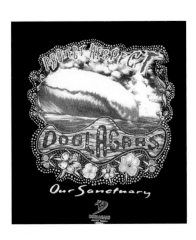

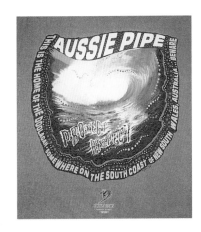

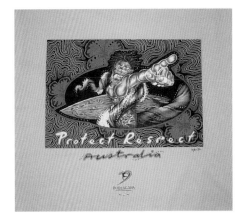

Teenage timeline, 1950s

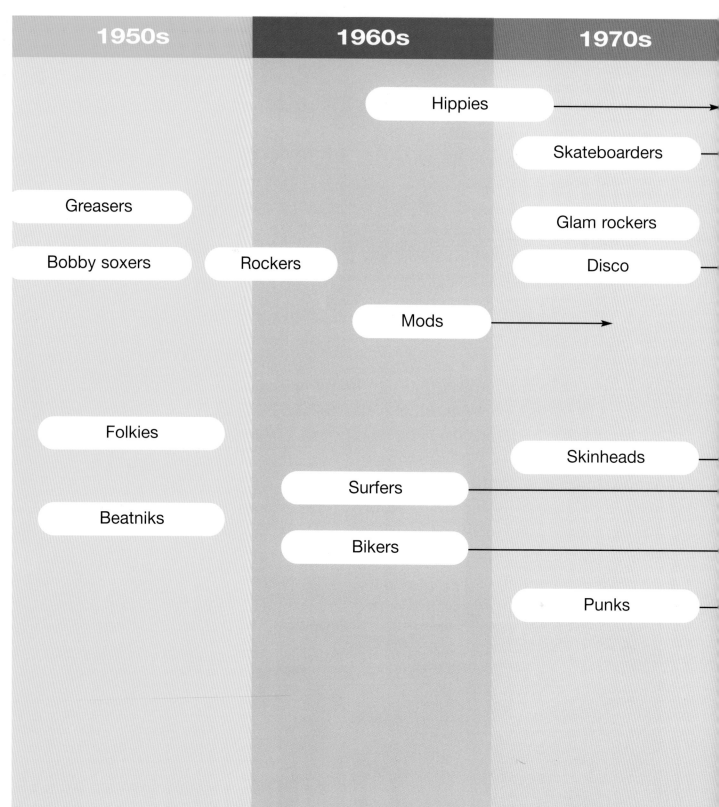

1950s	1960s	1970s
	Hippies	
		Skateboarders
Greasers		
		Glam rockers
Bobby soxers	Rockers	Disco
	Mods	
Folkies		Skinheads
	Surfers	
Beatniks	Bikers	
		Punks

–1990s

1980s	1990s

Grunge

Rockabilly

Preppies Ravers

Cyberpunks

Hip hop

Goths

New Wave

Hard Core

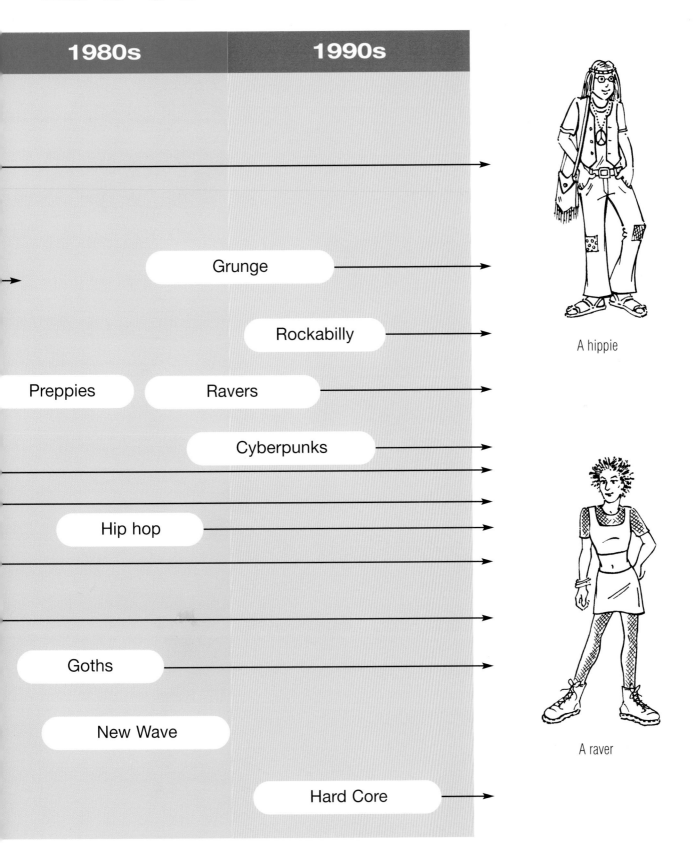

A hippie

A raver

Circus Oz

Shirts like the one pictured right have been worn by the performers and those who worked behind the scenes of Circus Oz. This shirt was designed by Hellen Sky who worked in Circus Oz. The shirt was worn by Kerry Dwyer, who operated the lighting, sold tickets and played the trumpet.

Circus Oz performs without using animals and was formed in 1978 in Melbourne.

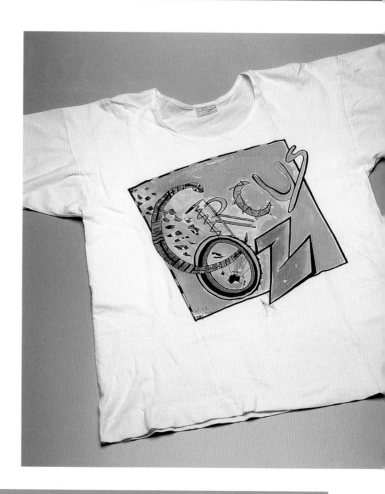

▶ A Circus Oz T-shirt made in Australia around 1981 by silk-screening the picture onto a cotton shirt.

What they were wearing then

This is a very famous statue called Manneken-Pis. The statue is in Belgium. It is of a little boy who is known for what he is not wearing. The story has it that he was the son of a wealthy family and that he disappeared. His parents said they would make a statue of him exactly as he was found. He was found wearing nothing and going to the toilet! Kings, presidents and celebrities have given clothing to the Manneken-Pis. He now has a wardrobe of more than 250 outfits, which are housed in the Musée Communal. If you go to **www.trabel.com/brussel-manneken.htm**, you may see the current outfit of Manneken-Pis.

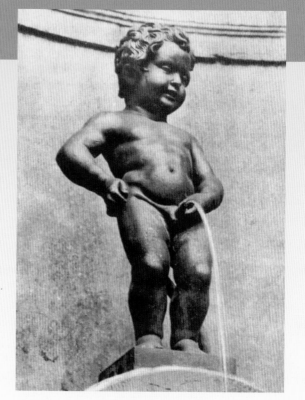

A Brolga dress

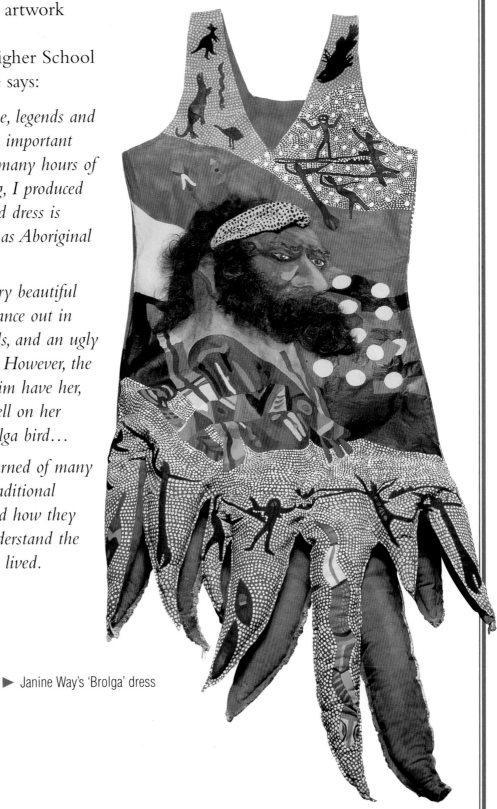

This dress was the major artwork created by Janine Way of Coonabarabran for her Higher School Certificate in 1990. Janine says:

The Aboriginal Dreamtime, legends and their way of life are a very important part of my heritage. After many hours of study, drawing and reading, I produced 'Brolga'. My hand-painted dress is based on things that I see as Aboriginal culture…

The story is about a very beautiful young girl who loved to dance out in the paddocks with the birds, and an ugly elder who wanted the girl. However, the girl's tribe would not let him have her, so the ugly elder cast a spell on her and turned her into a Brolga bird…

In doing my dress, I learned of many Dreamtime legends, the traditional Aboriginal ways of life and how they survived. It helped me understand the way of life that my people lived.

▶ Janine Way's 'Brolga' dress

Making a statement

This is Andy and Deanne. They make their own clothes and combine them with others to invent a 'look'. They want to create something original and not be part of any set group of people. Their clothes are an important part of who they are and what they do for work and fun. They have many influences—things that inspire and interest them such as this KISS figurine (pictured right).

Andy and Deanne love to dress up, even to go shopping. Here we see them dressing to have dinner with friends.

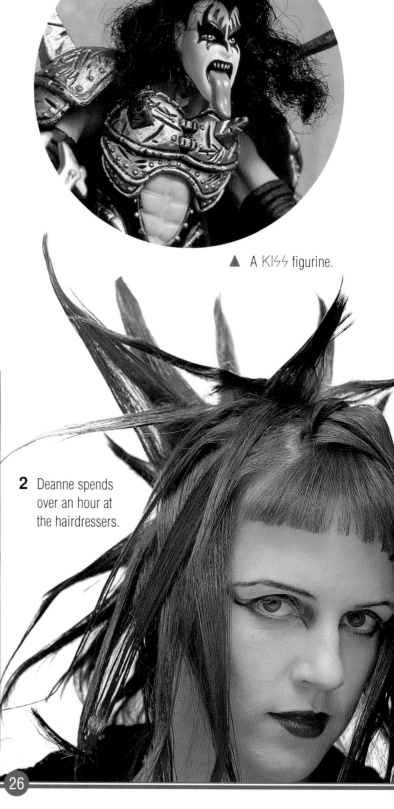

▲ A KISS figurine.

1 Andy helps Deanne with her make-up.

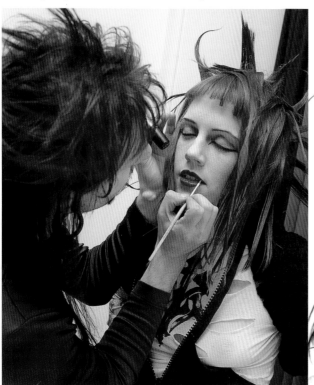

2 Deanne spends over an hour at the hairdressers.

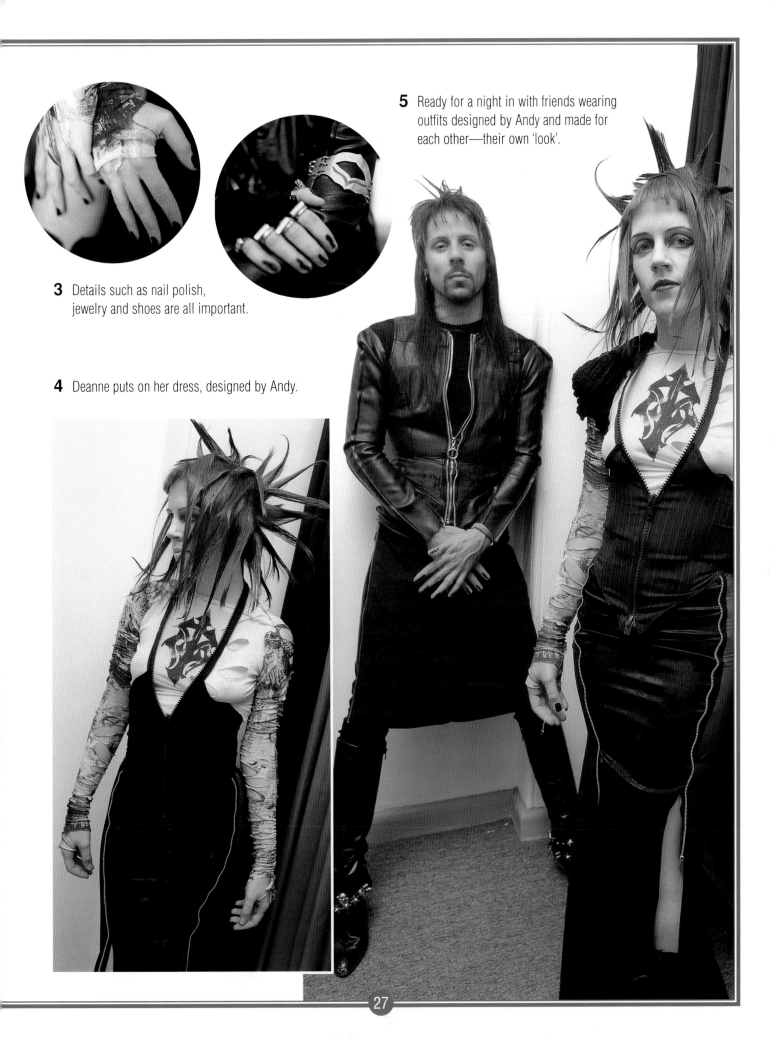

3 Details such as nail polish, jewelry and shoes are all important.

4 Deanne puts on her dress, designed by Andy.

5 Ready for a night in with friends wearing outfits designed by Andy and made for each other—their own 'look'.

Men and women wear special clothes when they get married. In ancient Rome, the bride wore a white wool dress with a **girdle** around her waist tied with a knot. She wore a red veil and flowers in her hair. In the early 1800s in Europe, brides wore long white dresses and veils—a tradition that continues in some countries today.

In northern India, brides wear red and yellow to ward off demons. The bride prepares the groom's clothes. She folds the lower half of the robe into **pleats**.

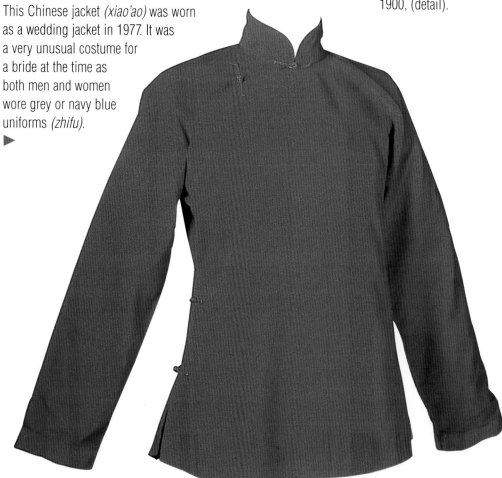

▲ A wedding **sinh** made of silk and cotton, from Laos, 1900, (detail).

This Chinese jacket *(xiao'ao)* was worn as a wedding jacket in 1977. It was a very unusual costume for a bride at the time as both men and women wore grey or navy blue uniforms *(zhifu)*.
►

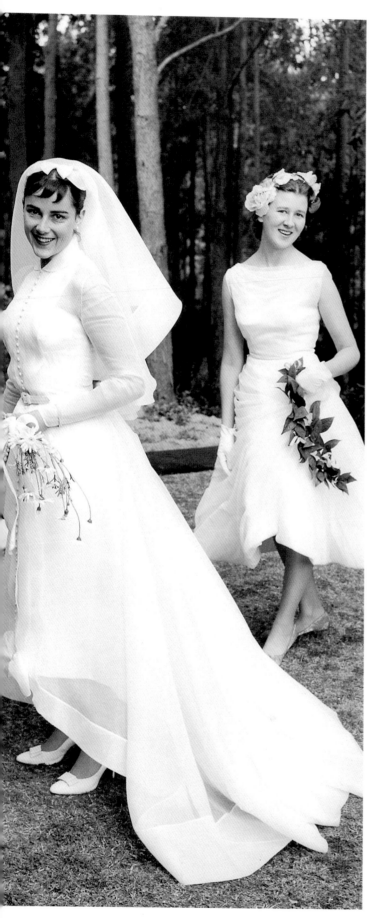

An Australian wedding photograph, 1958. The wedding dress was designed by Bill Lutton. The veil is by Freddy Fox.

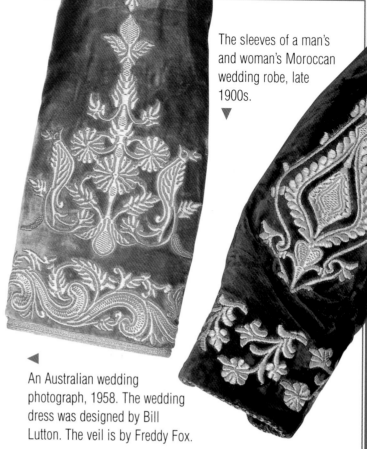

The sleeves of a man's and woman's Moroccan wedding robe, late 1900s.

Traditional Malayan brides wear so much gold and silver jewelry that they cannot walk and must be carried.

In Japan in the 1800s, the bride wore a thick cover made of silk to hide her face. Her face was covered in rice bran and painted white. Her lips were painted red and her teeth were painted black.

In Hindu marriages, the bride and groom's garments are tied together. The phrase 'tying the knot' may be based on this Hindu practice.

CHALLENGE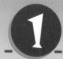

Where is Gretna Green?

The answer is on page 30.

Clothes say a lot

'**I** don't care about fashion,' a friend may say. 'I wear what I like!' Whether or not you care about what is in fashion for your age or group, your clothes say something about you—even if it is that you do not care what you look like. Some people may have no choice in what they wear. They must wear certain clothes to stay in a job, be part of a club or even a member of a family. Just like the pictures in a book can tell a story, clothes can tell other people about the wearer.

▶

This outfit, called 'Land rights', was made by Aboriginal designer Bronwyn Bancroft in 1987. The colors in this outfit are the same as in the Aboriginal flag. Yellow is for the sun, the giver of life; black is for the Aboriginal people; and red is for the land and the people's relationship to it.

Answer

Page 29
In Scotland. Gretna Green was where people often went if they wanted to be married in secret.

Glossary

civil a matter having to do with citizens or the government

court the palace of royalty and the people who live or work there

deck the top of a skateboard, where you put your feet

girdle a belt or cord worn around the waist, or a piece of elastic that supports your stomach or hips

habits the clothes of people in a religious order

heraldic to do with coats of arms and family histories

Indigenous native to a particular area or country. Aboriginal people are the indigenous people of Australia

insignia badges or marks to show positions of honor

Koori an Aboriginal person from parts of New South Wales and Victoria

mourning feeling or showing sorrow over someone's death or the loss of something

murex a shell common in tropical seas

pleats pressed or stitched folds in trousers or a skirt

pomegranate a thick-skinned, pinkish fruit that splits open to reveal many seeds

regalia symbols and emblems of royalty or status, such as a crown

sari a very long piece of colored silk and/or cotton, wrapped around the body as a skirt and over the shoulder. The sari is the most important part of the Hindu woman's dress

sinh the traditional wrap-around skirt of Laotian women, usually of ankle length

Index

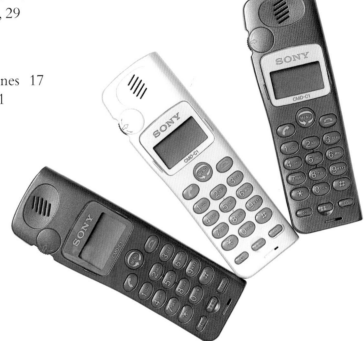

Photo credits

All objects featured in this publication are from the Powerhouse Museum collection, unless otherwise indicated. The Museum acknowledges the many generous donations of objects, which form a significant part of its collection.
★ Indicates photographs of museum objects reproduced with the permission of the designer or maker. Photographs are by the Powerhouse Museum unless otherwise indicated.

Cover: Baggy green cap, Australian Cricket Board; Brolga dress★ by Janine Way; Deanne Eccles.
Title page: Baggy green cap, Australian Cricket Board.
Border detail: Skateboards, courtesy Skateboard World.
Page 3 Skateboards, courtesy Skateboard World; page 4 Funkessentials poster★ by Sara Thorn and Bruce Slorach; page 6/7 Nurses in uniform, photos courtesy Museum of Nursing, Royal Prince Alfred Hospital and The New Children's Hospital, Westmead; page 8 Quong and Margaret Tart, photo courtesy Mitchell Library, State Library of NSW; page 12 Baggy green cap, photo courtesy Albion Hat & Cap Co and Australian Cricket Board; page 17 Mobile phones, photo courtesy Sony; page 18 Simon Siounis; Skateboarder, photo by Curtis Mah, courtesy Mah Media; page 19 Mambo poster★ by Reg Mombassa for Mambo Graphics; clothing, photos courtesy Mambo Graphics; pages 20/21 Shayne Martin and Steve Dixon surfing, T-shirts, photos courtesy Doolagah Surf Products; page 24 T-shirt★ by Hellen Sky for Circus Oz; page 25 Brolga dress★ by Janine Way; pages 26/27 Andy and Deanne, Andy Christ and Deanne Eccles; page 30 Land rights outfit★ by Bronwyn Bancroft; page 31 Shirt, photo courtesy Mambo Graphics; page 32 Mobile phones, photo courtesy Sony.

Please visit the Powerhouse Museum at **www.phm.gov.au**